How to Draw
Dinosaurs
In Simple Steps

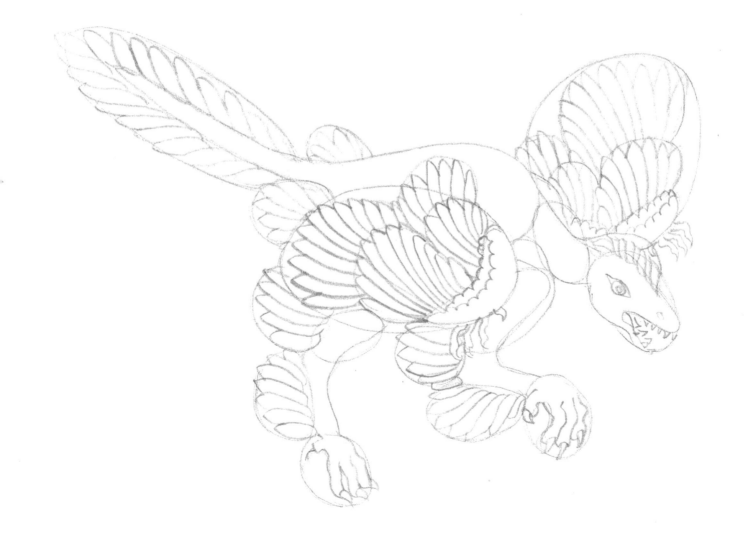

First published in Great Britain 2012

Search Press Limited
Wellwood, North Farm Road,
Tunbridge Wells, Kent TN2 3DR

Text copyright © Dandi Palmer 2012

Design and illustrations copyright © Search Press Ltd. 2012

ISBN: 978 1 84448 871 1

Printed in Malaysia

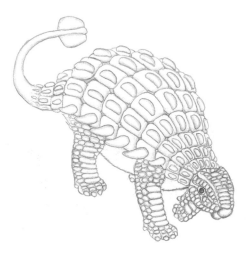

Dedication

*Dedicated to the memory of Mary
Anning (1799–1847), freelance
fossil hunter*

Illustrations

How to Draw
Dinosaurs
In Simple Steps
Dandi Palmer

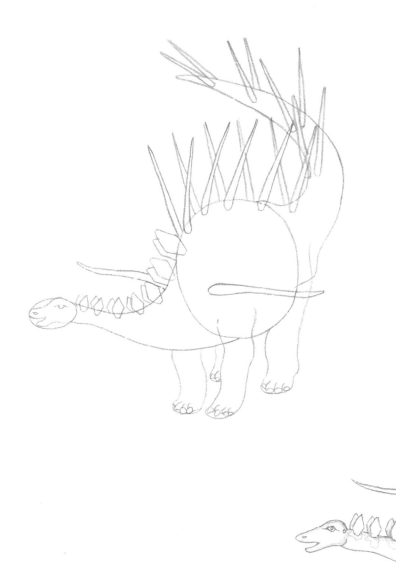

Search Press

Introduction

Large and lumbering, fierce and fast, dinosaurs used to fill every niche that mammals now occupy. Today, palaeontologists are in the process of compiling a large zoo of these amazing creatures: the giant herbivores, the formidable predators that hunted them and the feathered ancestors of present day birds. The dinosaurs are reconstructed from rare, complete fossils, or just one or two bones and new specimens are still being discovered around the world today in areas that have not been explored.

Who wouldn't want to draw one of these beasts. Despite their extinction 65 million years ago, they managed to survive for over 230 million years before that. Unfortunately there are no snapshots for reference and nothing quite like a Tyrannosaurus exists today, unless there is a lost world tucked away on a plateau somewhere in the dwindling rainforests. However, many knowledgeable and skilful artists have used the evidence gathered by palaeontologists to transform fossils into living, roaring, munching, hunting beasts – creatures that existed in environments almost as removed from our own as those that microbes on Mars possibly evolved in. It is thanks to these artists that dinosaurs live on through television programmes, books and films. Animation has offered a fantastic glimpse into what it may have been like when dinosaurs walked the earth, from Winsor McCay's 1912 cartoon 'Gertie the Dinosaur' through to the fantastic computer graphics imagery of Jurassic Park.

While the fossilised, scaly hide of a Hadrosaur has been discovered, and the bodies of dinosaurs can be reconstructed with confidence now, their colours and patterns are conjecture. Also, some dinosaurs in the Cretaceous period lost their reptilian nature and they may have become warm blooded; apart from scales, it is now believed that many had feathers, possibly even fur. So, the colours and patterns in the illustrations are mainly fancy; feel free to change them as you choose, adding spots, stripes or other decorations to your pictures. Herbivores most likely blended with the foliage they browsed on, apart from those that were so huge that camouflage would have been pretty pointless. Other species could well have been brightly coloured to match their gaudy frills, feathers and horns.

In the first stage of each drawing sequence, the initial guidelines are sketched in brown pencil, and mauve is used to progressively build up the image. If you sketch your dinosaur in pencil, when you are satisfied with the result the key lines can be drawn in using a fine felt tip or pen, and the sketched lines can be erased. I have used coloured pencils for the completed images, although you may prefer to use another medium. Hopefully you will find the dinosaur of your choice in this collection, but if you choose to draw your own, when looking for anatomical clues that might help think about the rhinoceros or elephant for the torsos and limbs of the larger herbivores, and ostriches for the smaller, fleet-footed carnivores.

Happy Drawing!

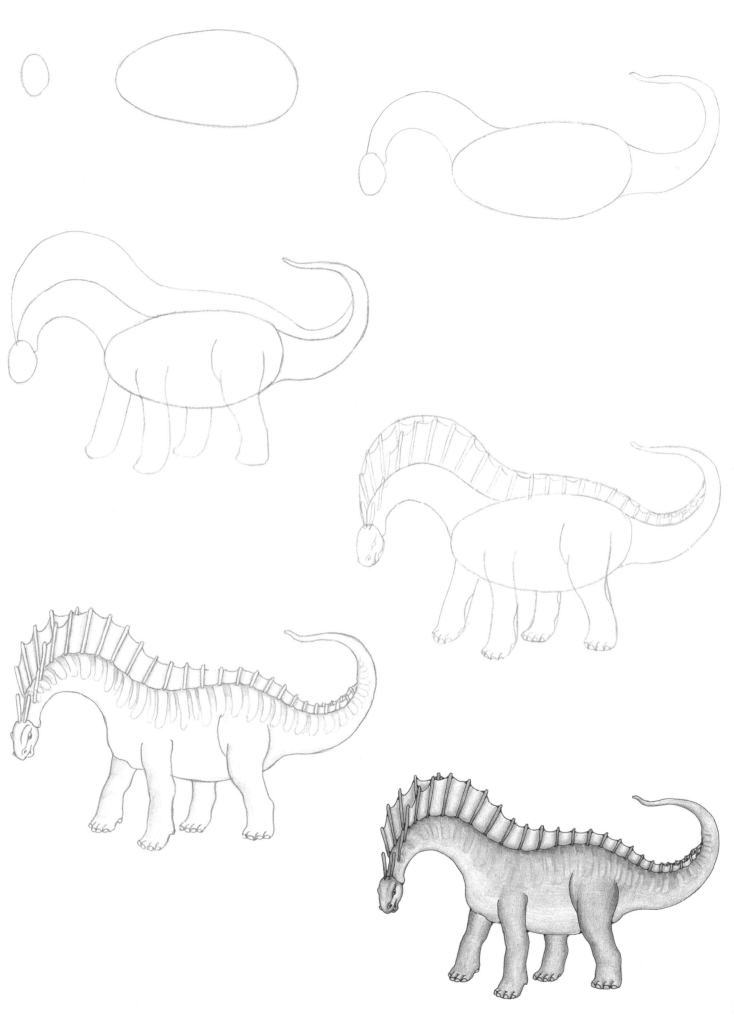

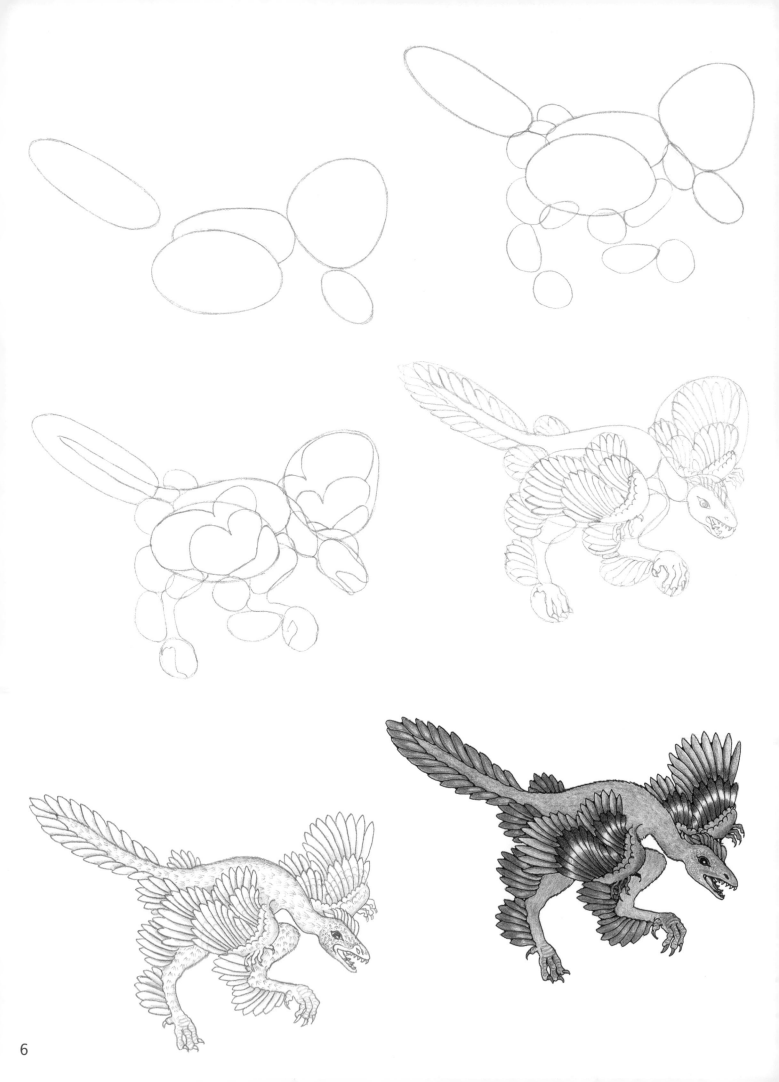

7

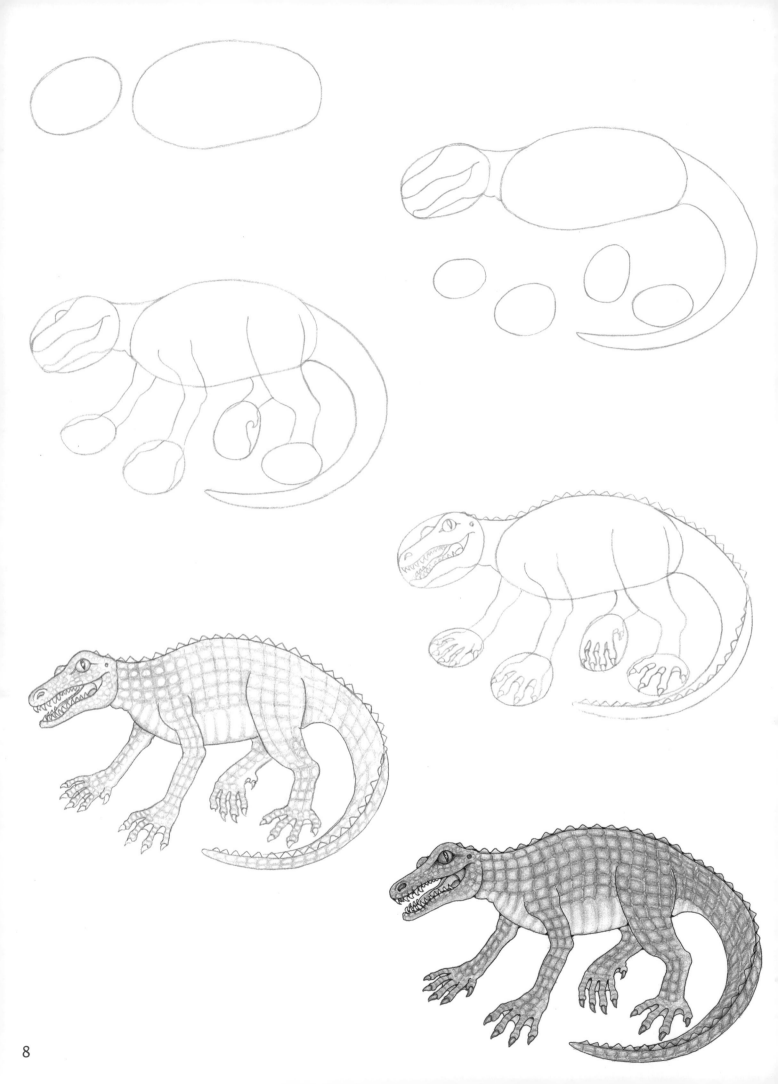

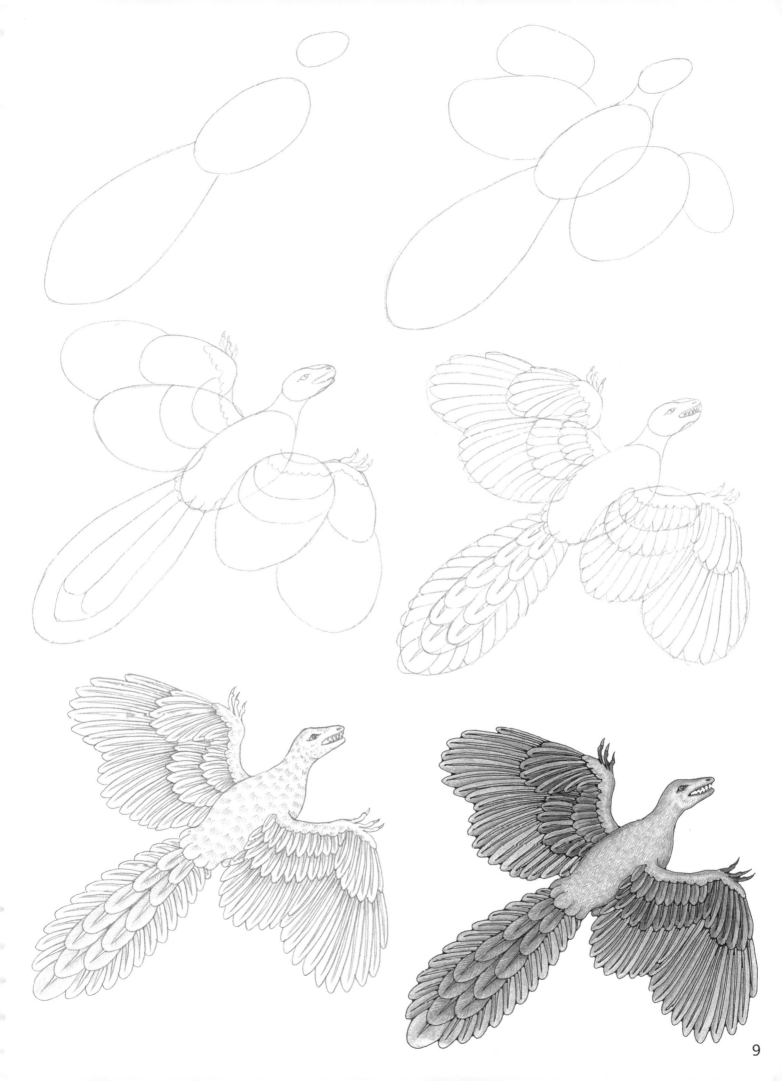

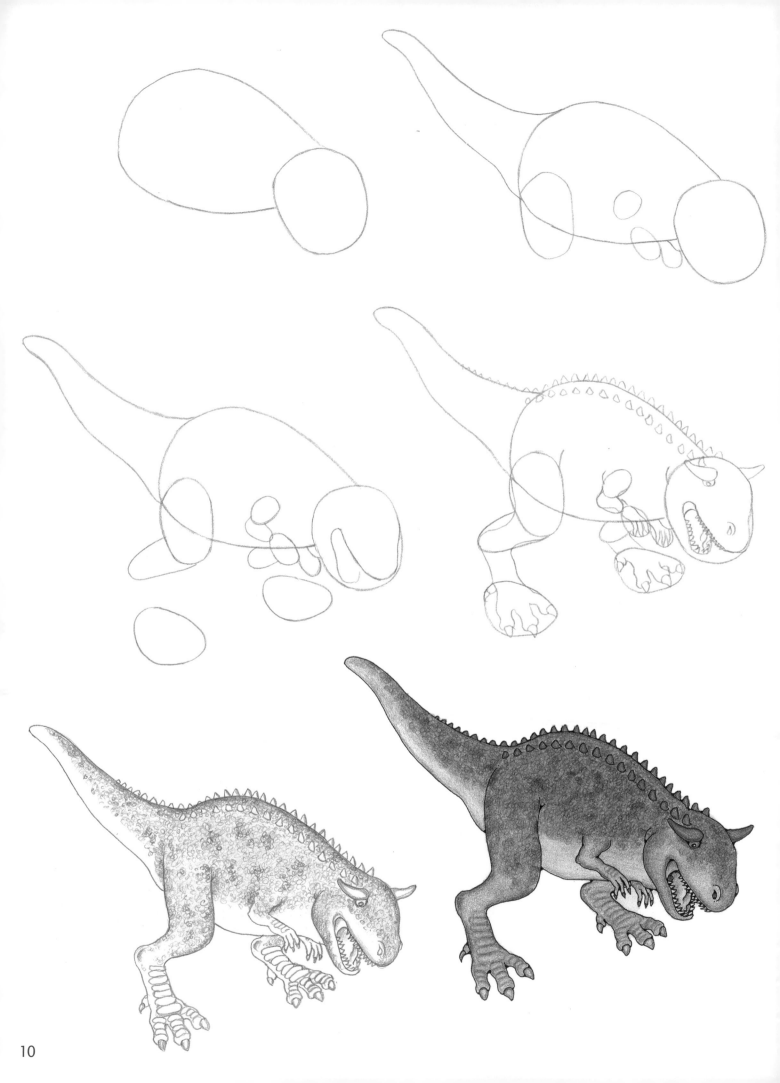

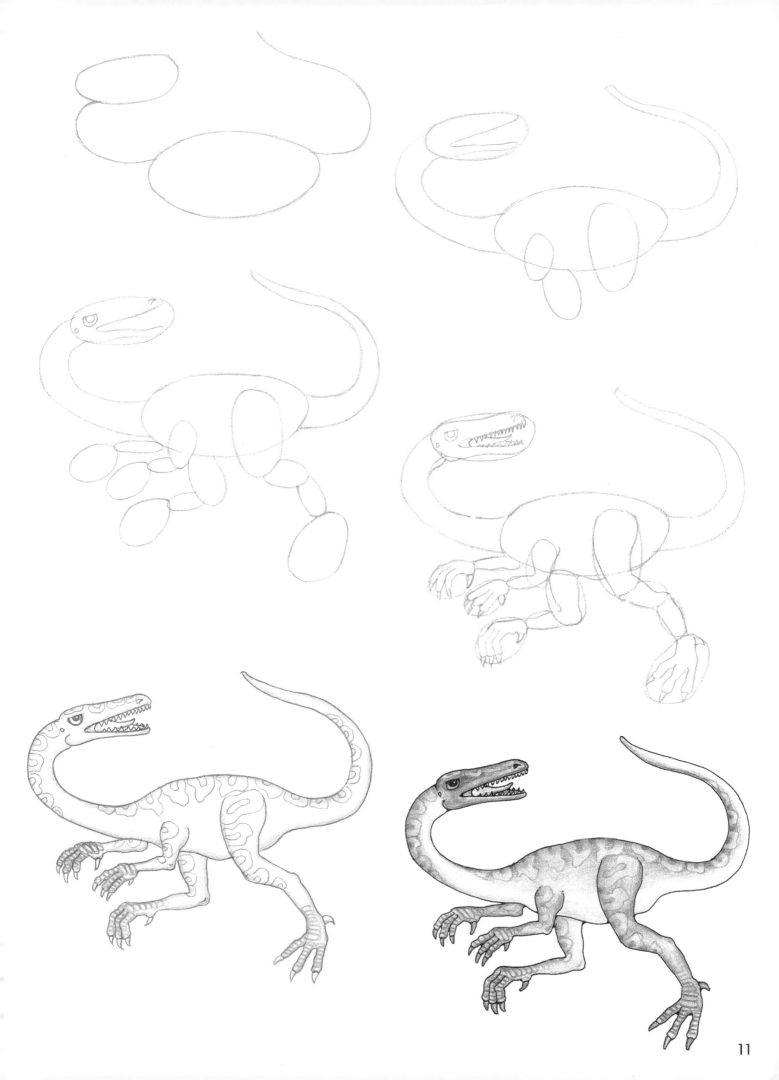

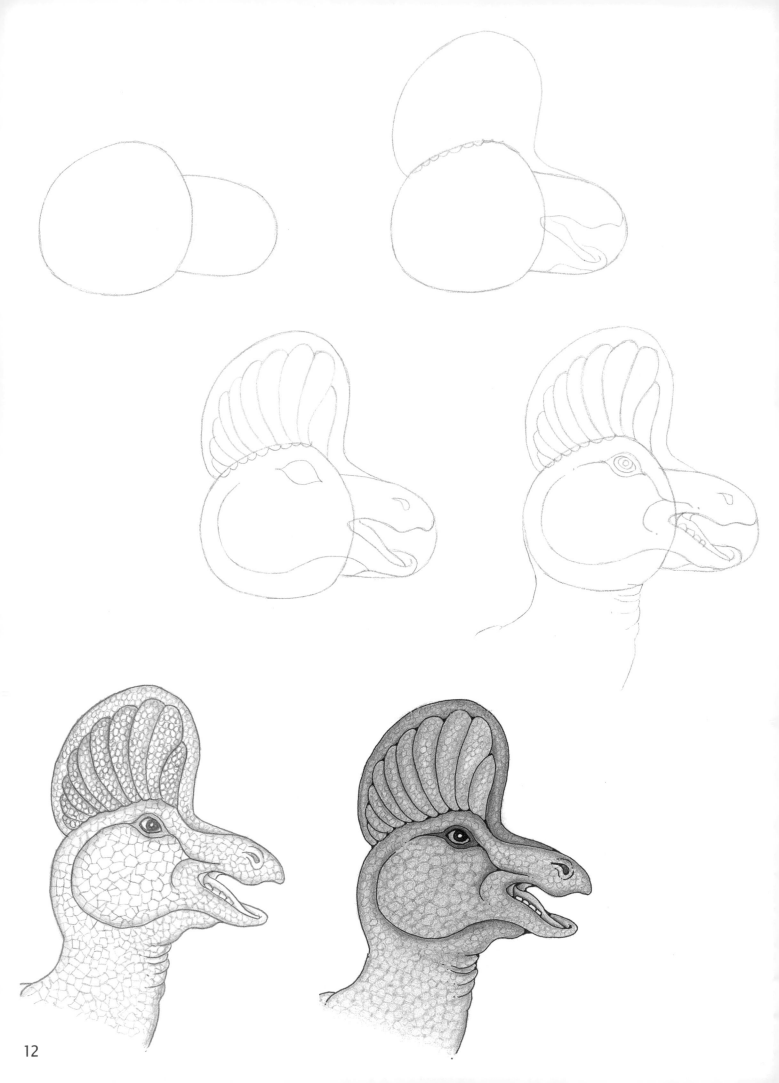

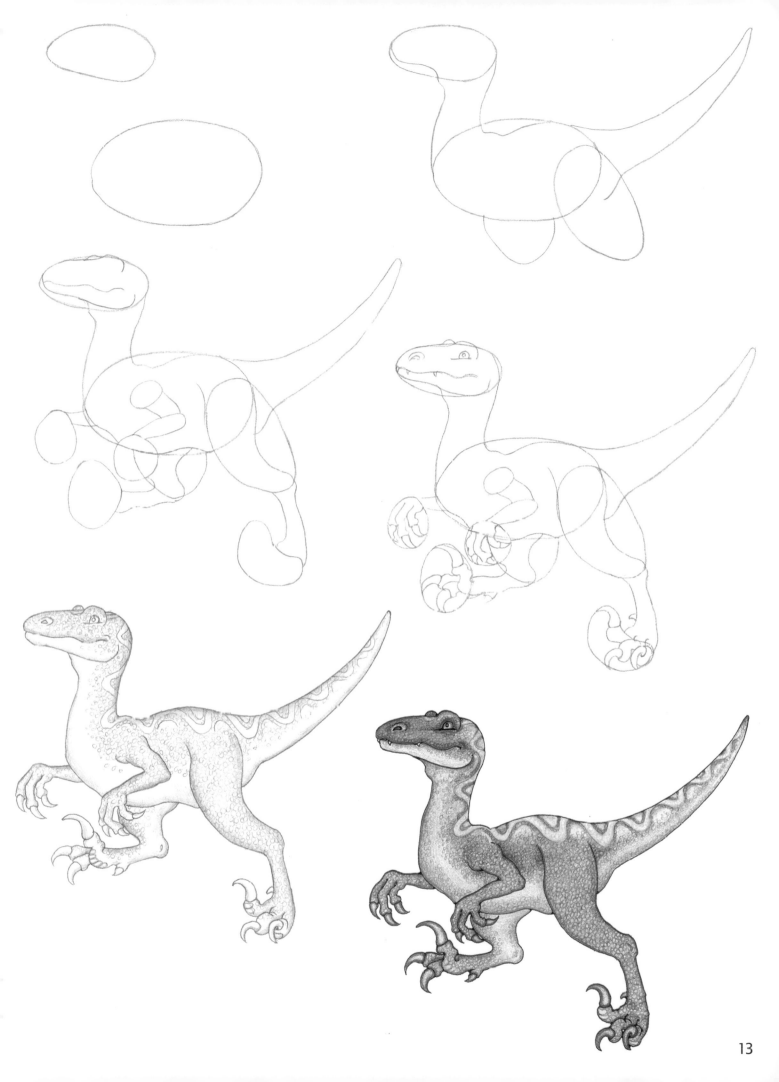

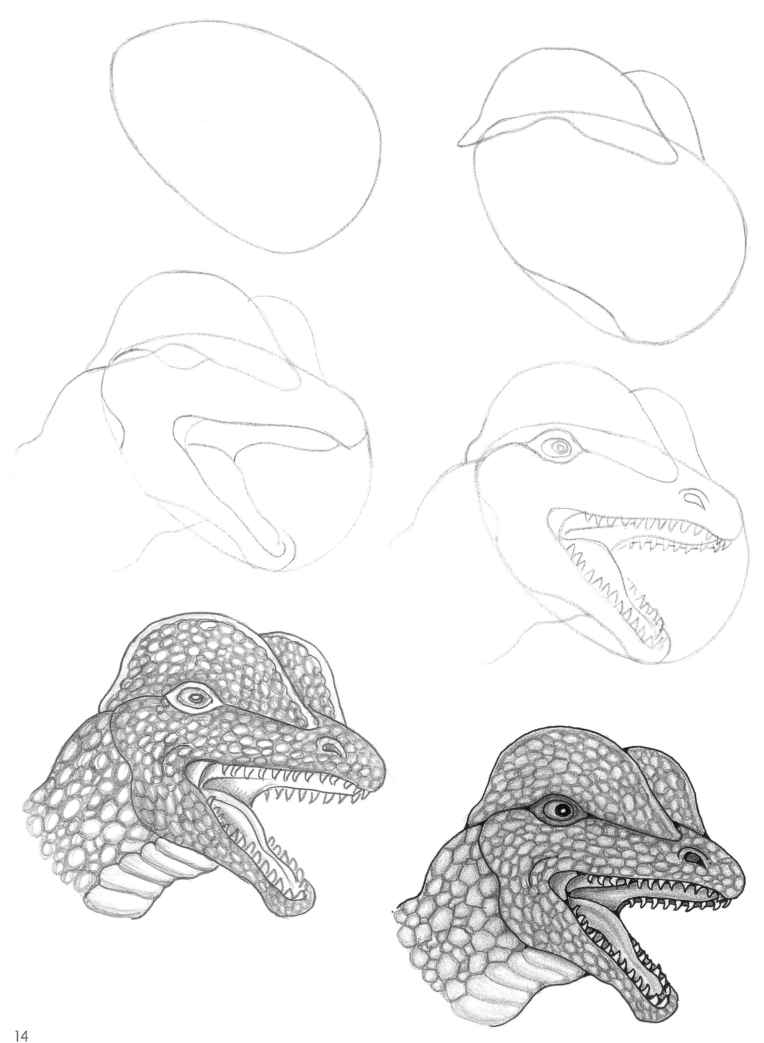

14

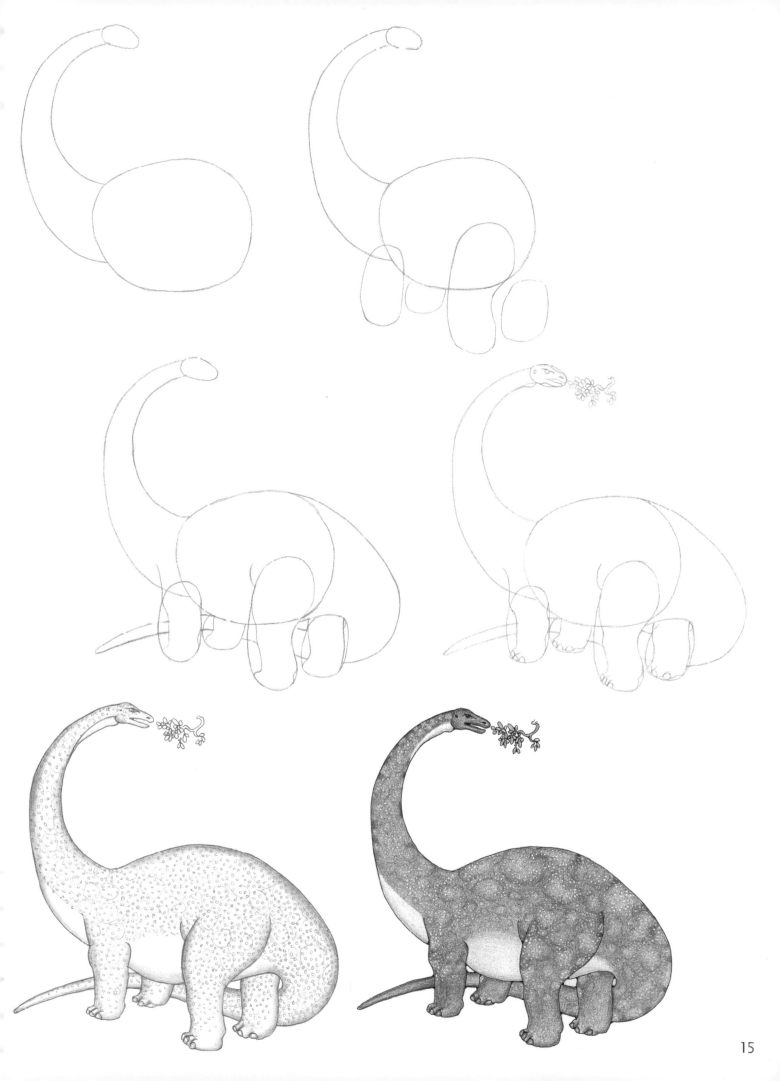

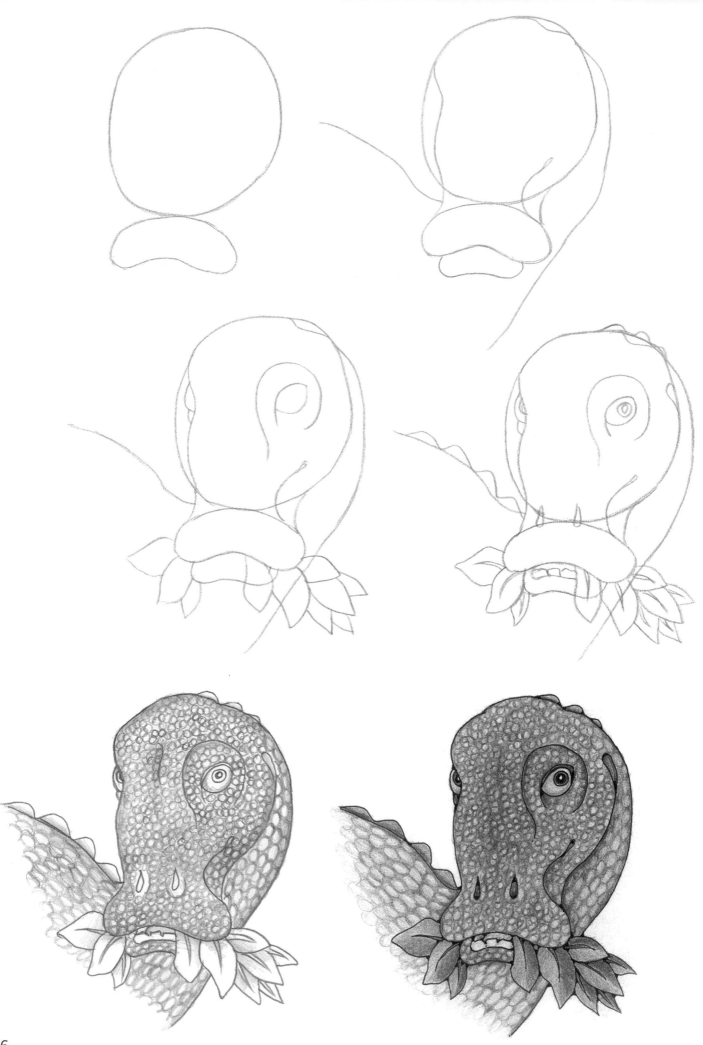

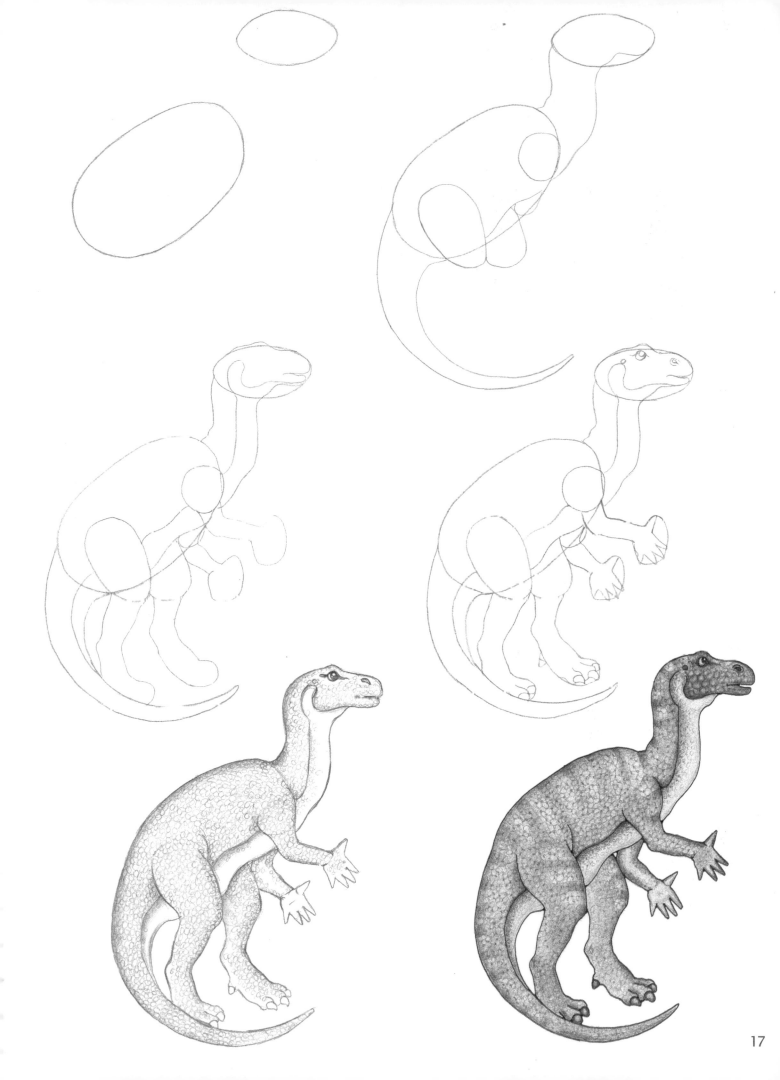

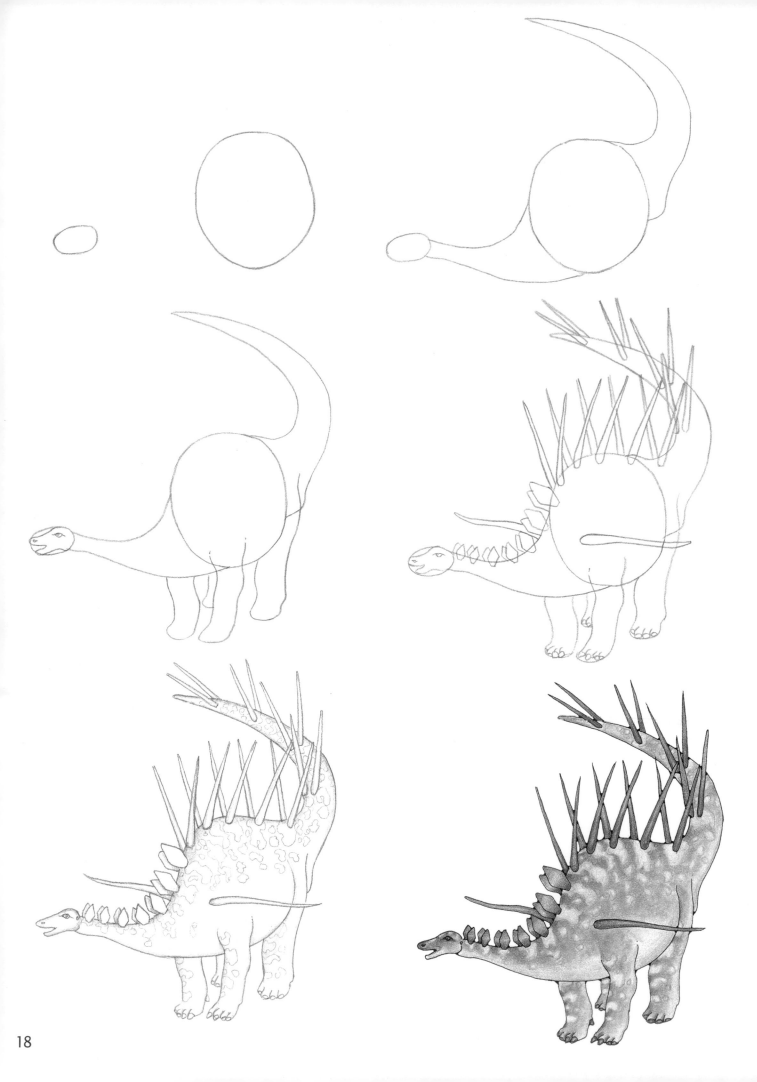

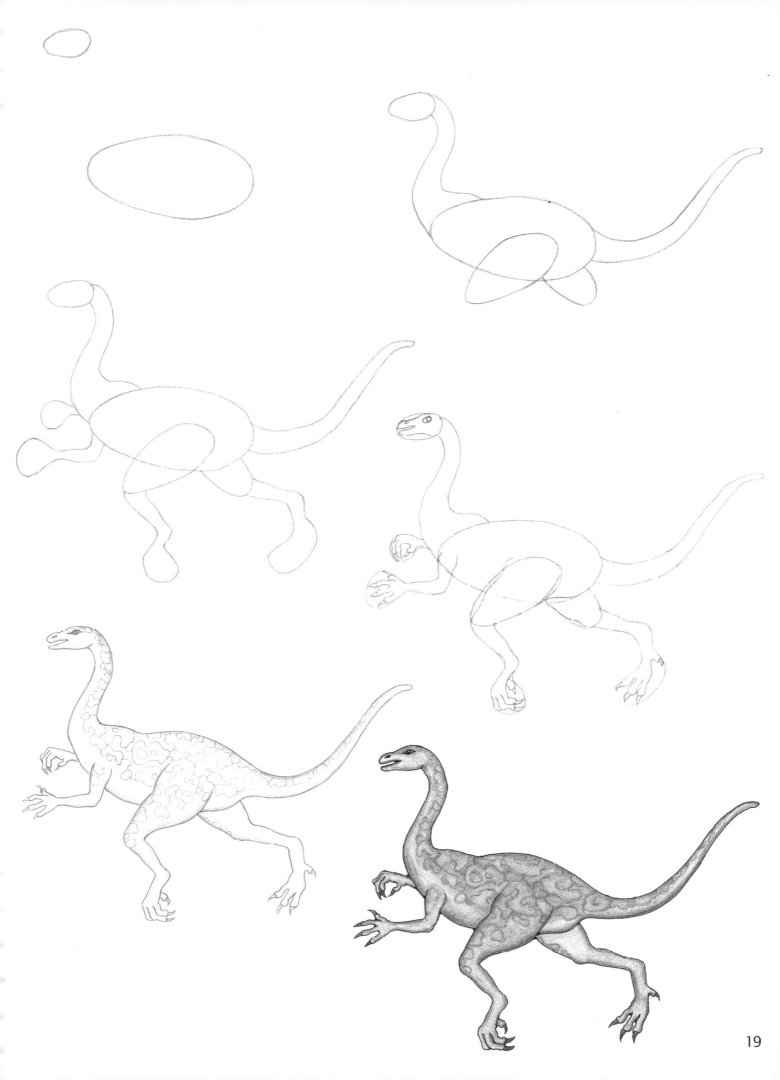

19

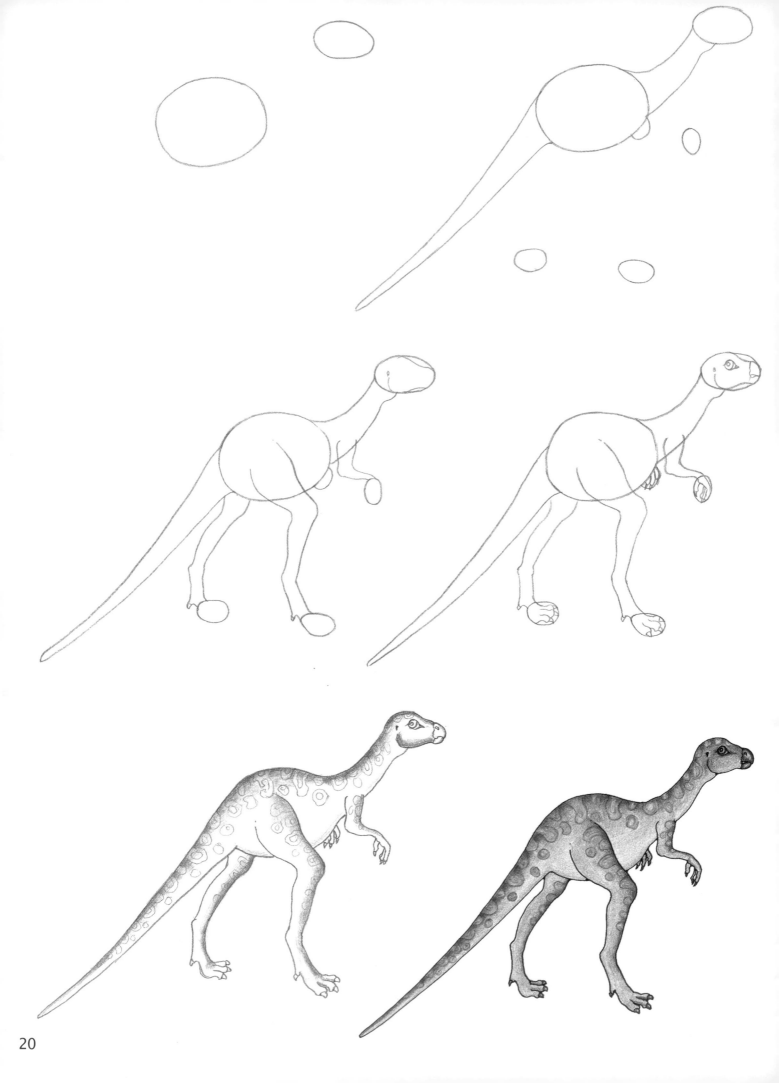

20

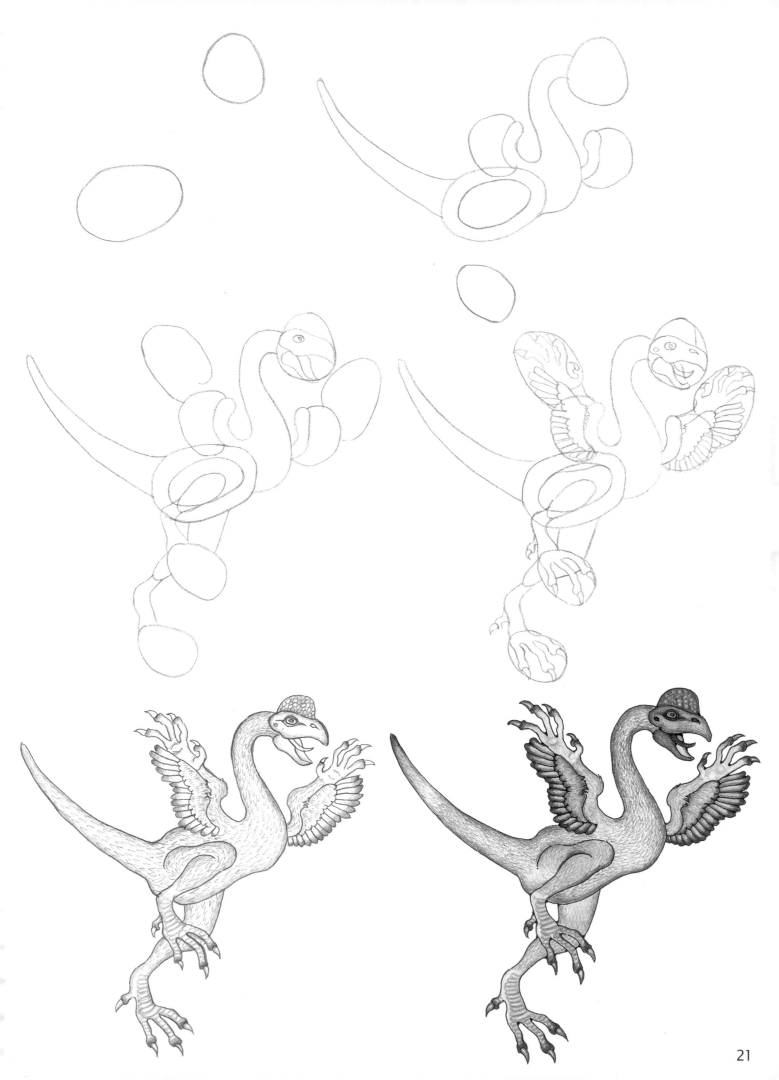

21

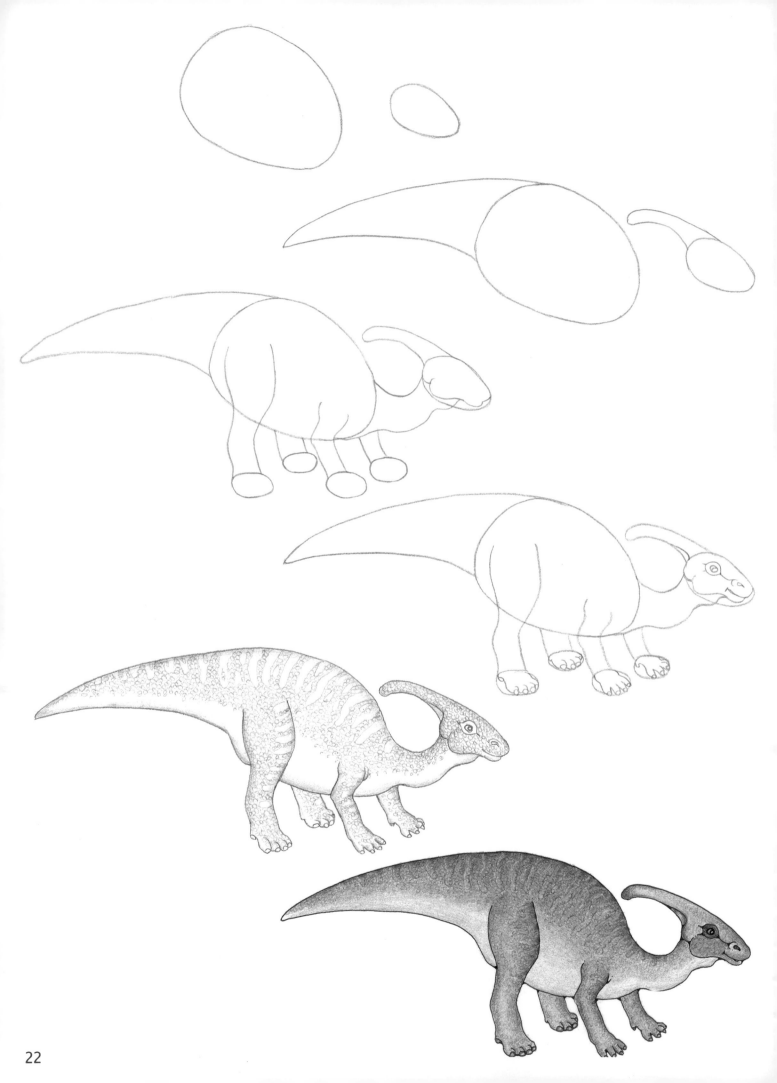

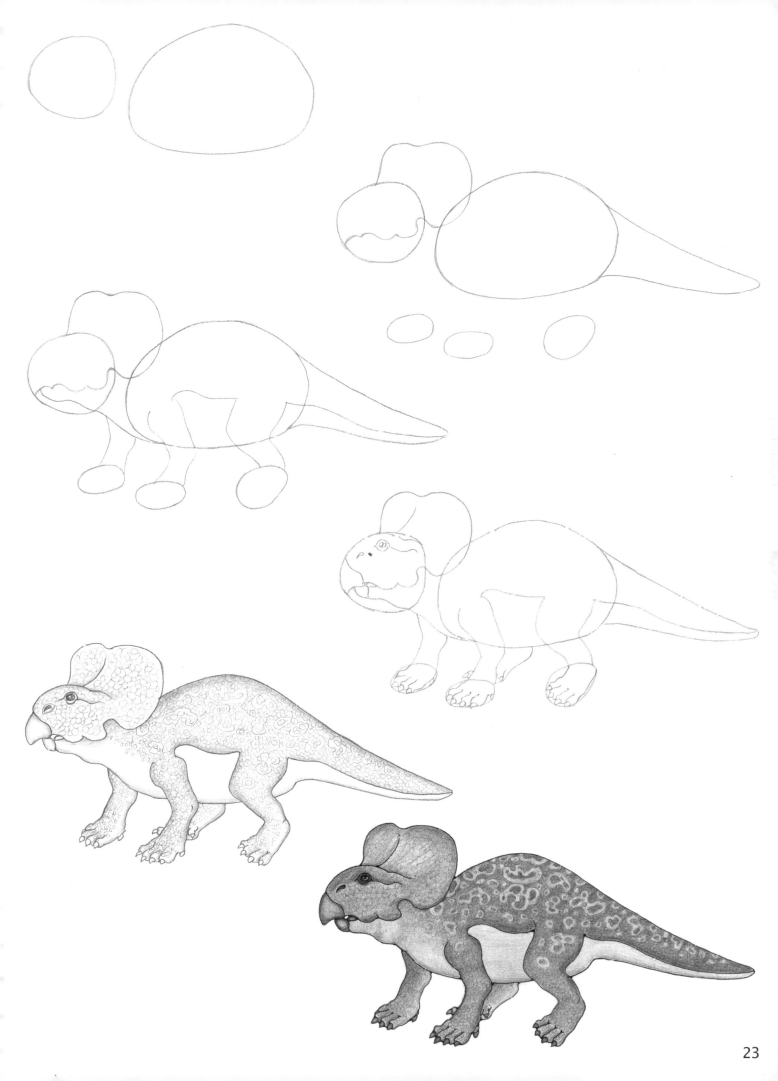

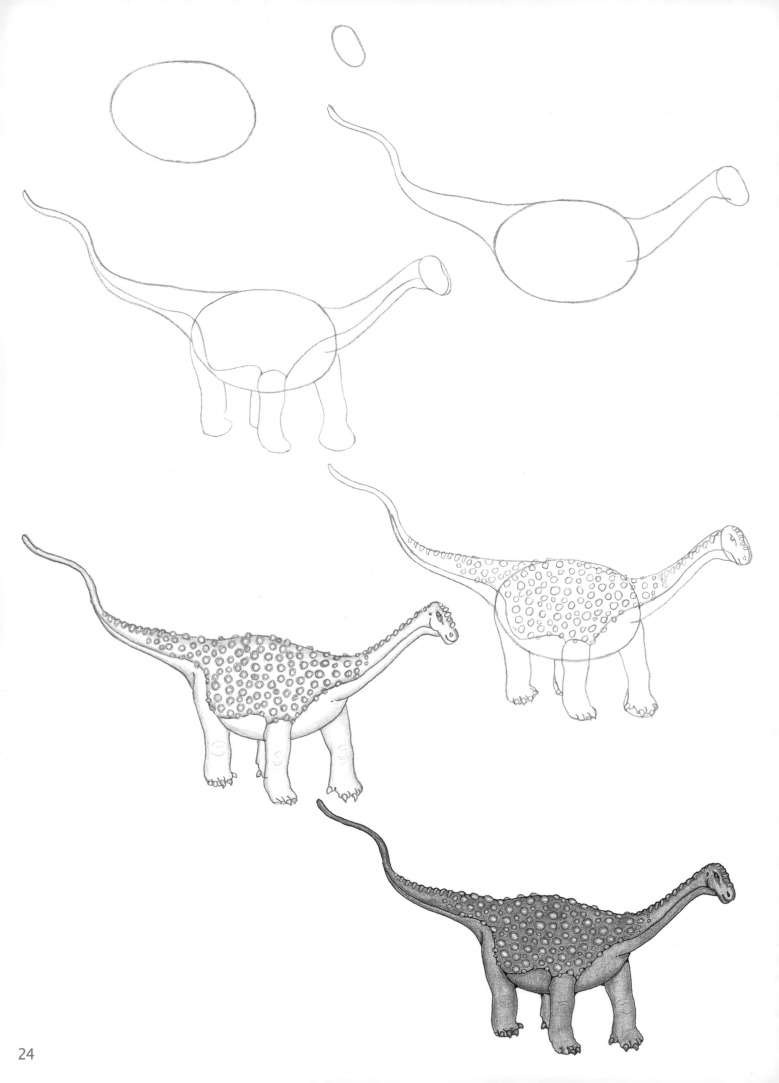

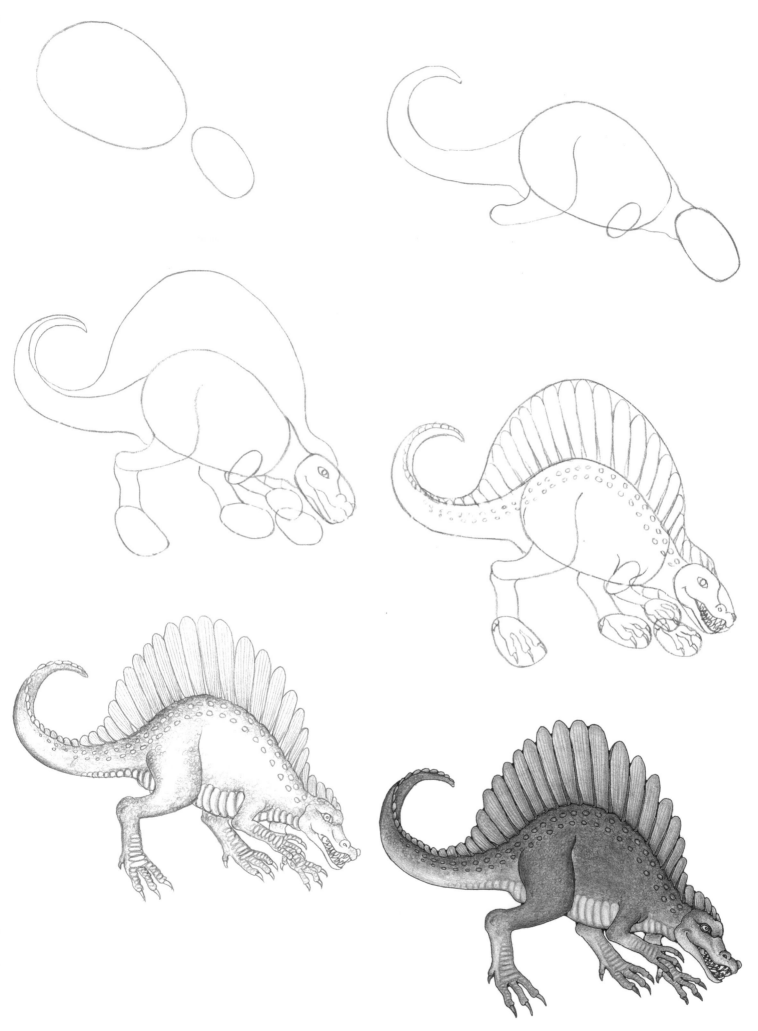

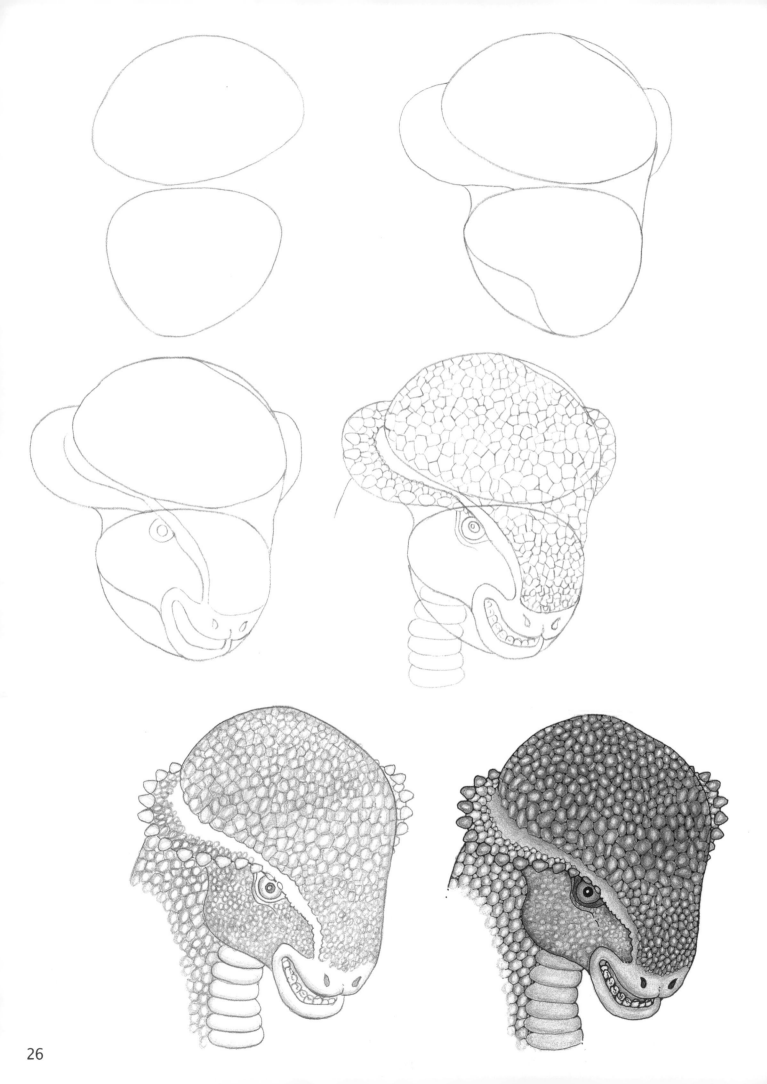

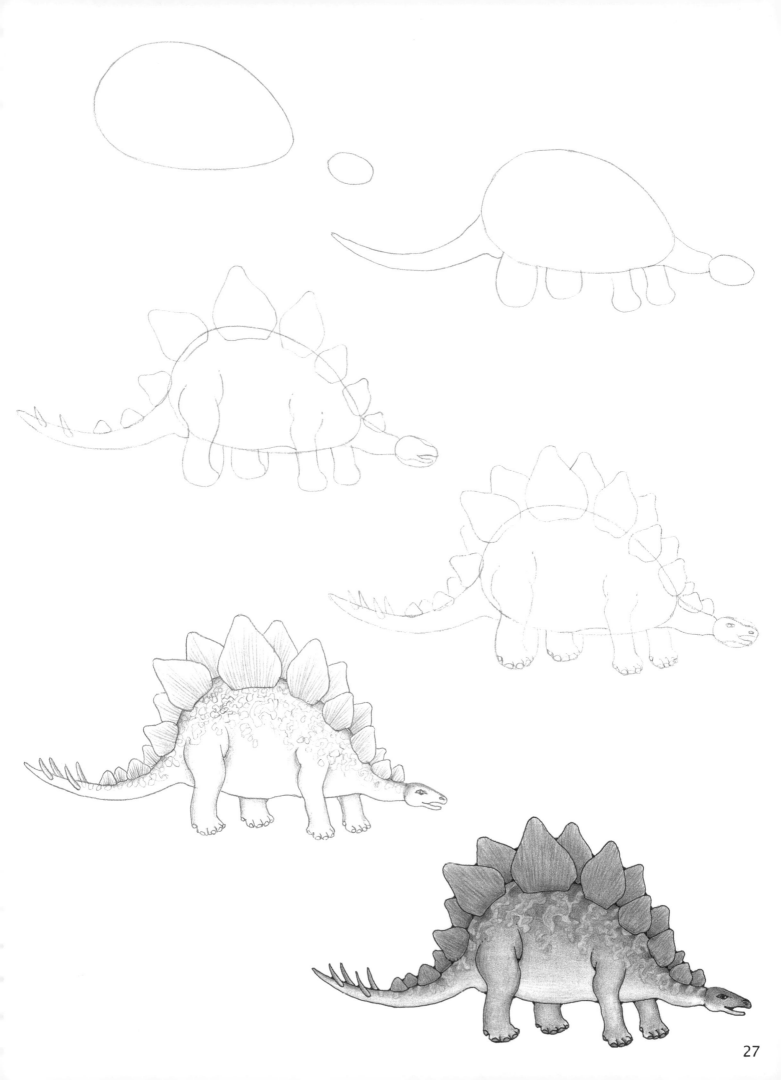

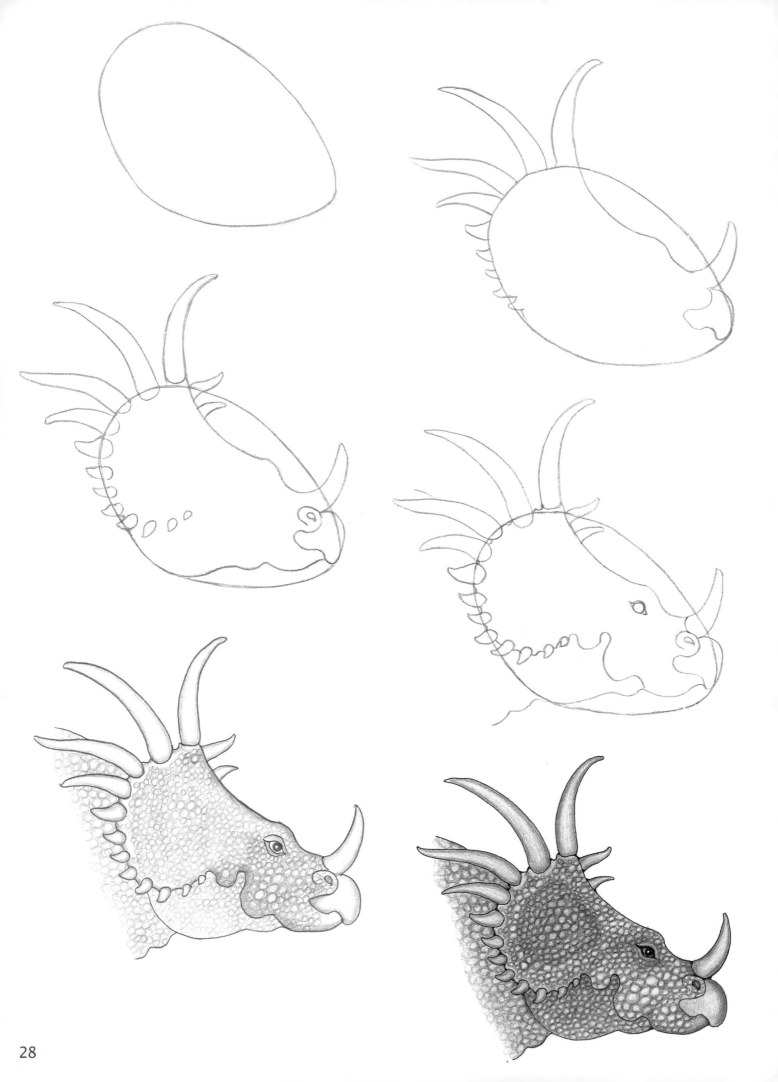

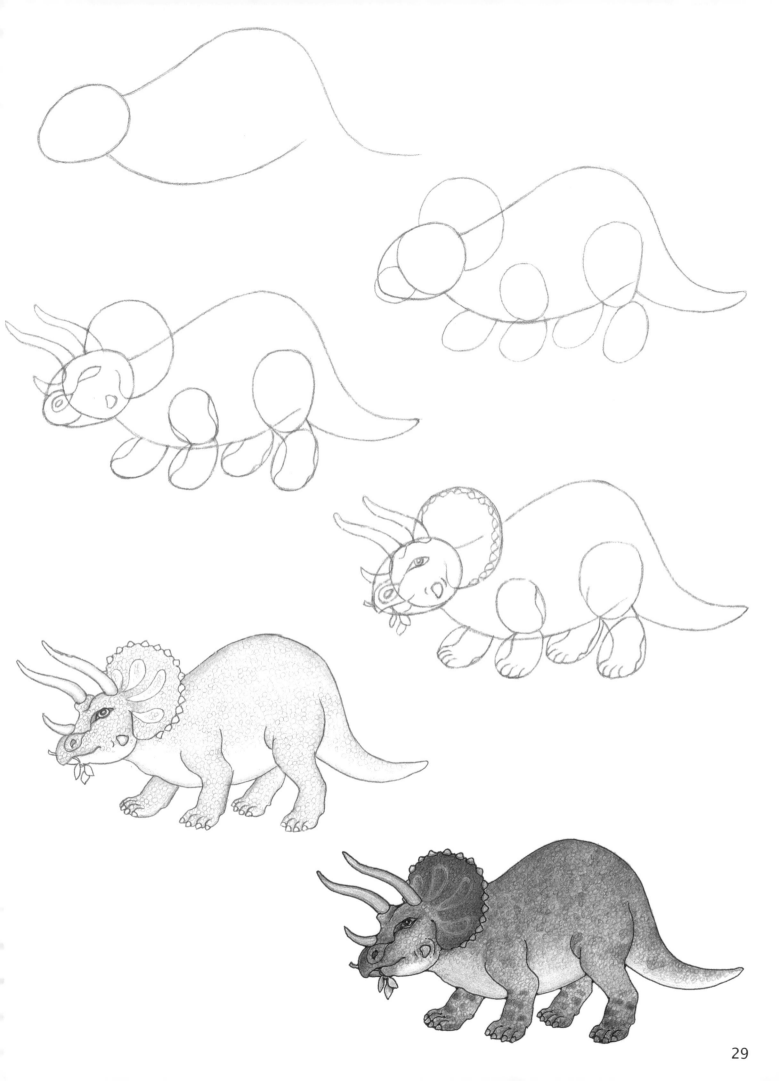

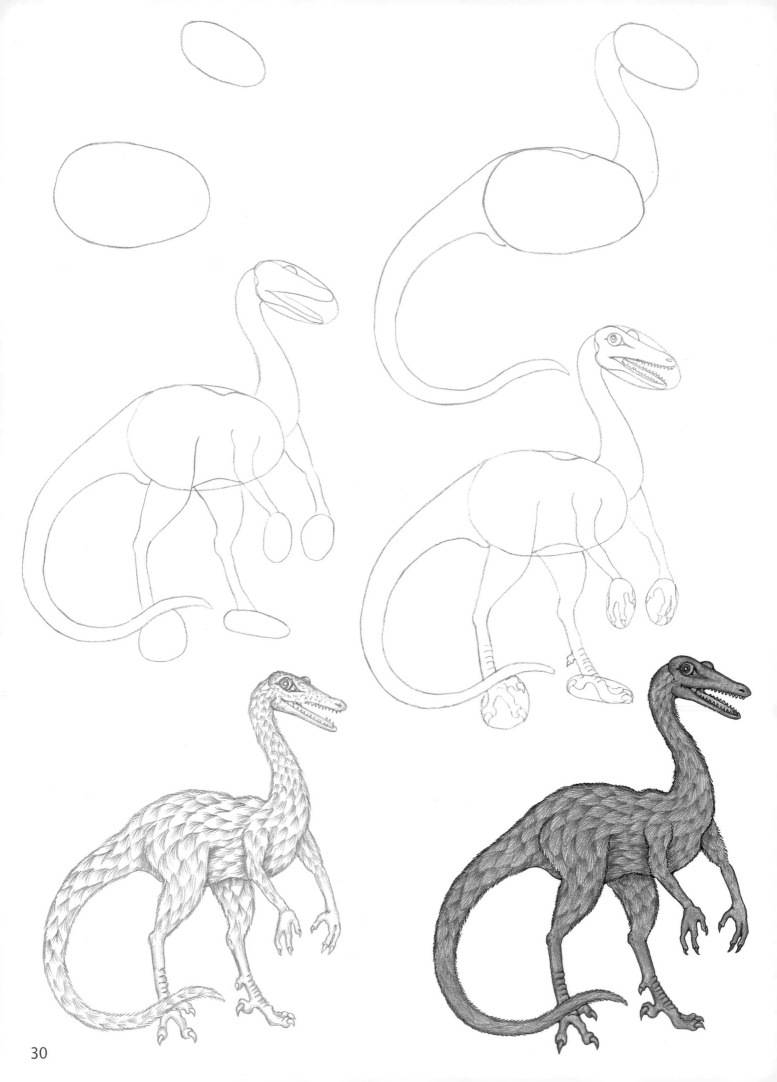

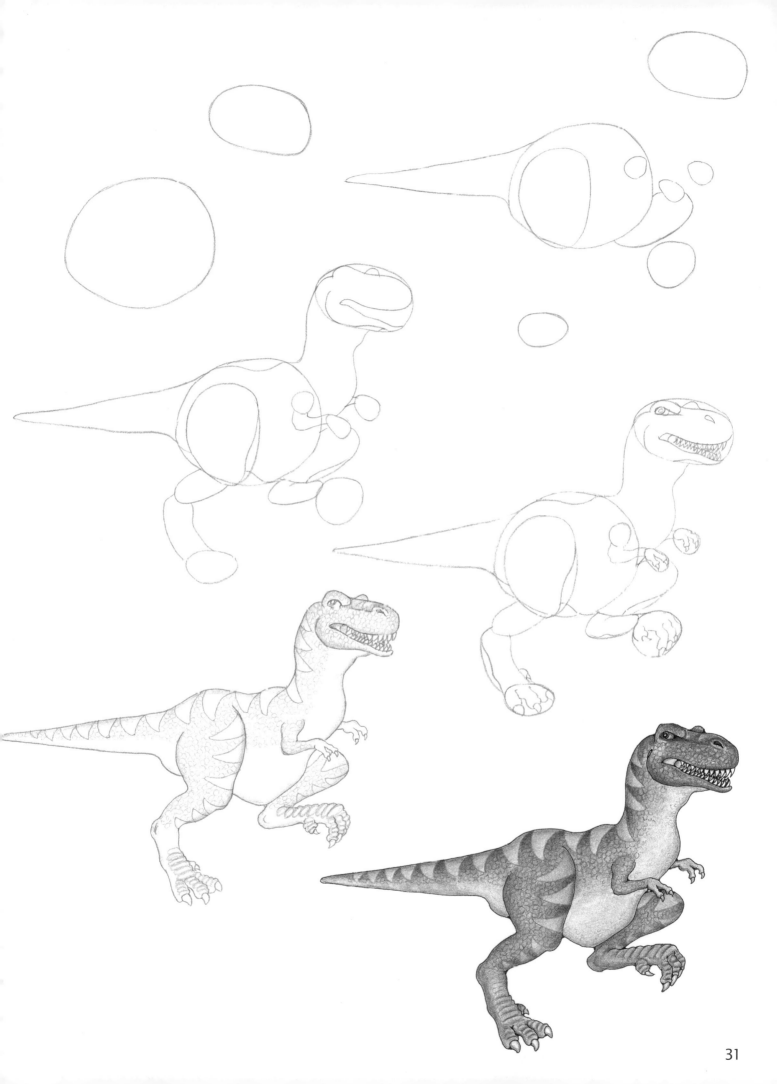

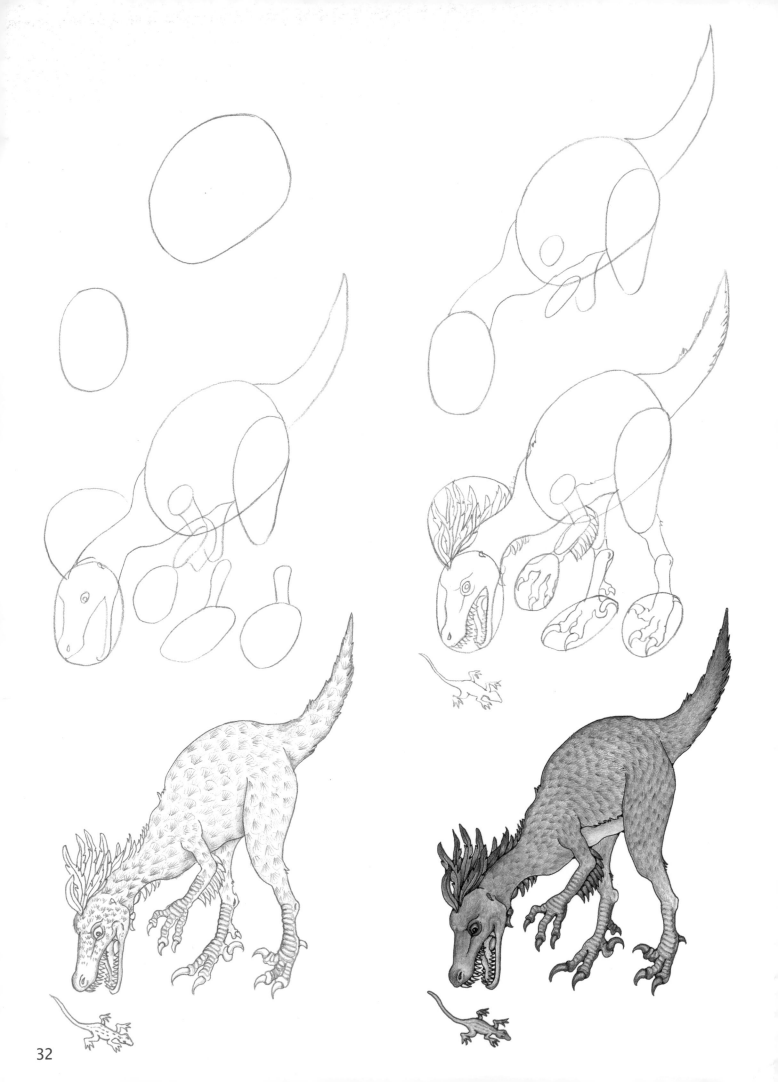